Three
Step
Watercolors

Jo MacKenzie

Green Frog Publishing • East Montpelier, VT

Three Step Watercolors
by Jo MacKenzie

Green Frog Publishing
P.O. Box 46
East Montpelier, VT 05651
www.greenfrogpublishing.com

First Edition

Written by Jo MacKenzie
Edited by Cecilia Bizzoco
Cover design by Green Frog Publishing
Cover paintings by Jo MacKenzie

ISBN 0991435915 EAN-13 978-0-9914359-1-3

Printed and bound in the United States of America.

This book is dedicated to Patience Tekulsky, Tom MacKenzie and to Julie Kirkland for being the first person who mentioned the word NOTAN to me.

Table of Contents

List of Figures

Part One
Preparation

Introduction

Introduction

Watercolor is my first love; in fact, I often jest that I write its name in all my notebooks and kiss it behind schoolyard fences. My feelings for watercolor are comparable to "puppy love." I love everything about the medium; but as with all great loves, I understand how frustrating it can be.

About two years ago, I began developing a three-step strategic approach to help me create pieces of art that at times surprise even me. In my quest to learn, I watched videos created by talented oil painters who I admire. And I was surprised to learn that they "mass their darks" and add lighter elements later. This technique was not how the introduction to watercolor books I read tended to describe the process. These books typically instruct would-be artists to either work from the lightest elements to the darkest, or use a series of light washes applied in layers to create a sense of volume and depth. So I decided to try approaching my watercolor art using the methods for oils, which is to mass your darks first and save your lightest elements for later.

Necessity is the mother of invention, and my **Three Step Watercolors** is no exception. I was looking for a process that didn't require hours of bending over a table or working with at an easel to create intricate paintings. While I admire and love complex paintings, I realized that I needed a faster, more direct process that better suited my personality and temperament.

During my first career as a Special Education teacher, I had to practice "task analysis." Task analysis involves breaking down a complex task into smaller,

Introduction

more digestible components, and allows students with special needs to learn and understand complex tasks by approaching them in small increments. I used this strategy when developing a plan for teaching students complex skills to help them attain mastery of a variety of subjects.

In the world of Special Education, this type of plan is called an I.E.P. or an Individual Educational Plan. I needed to develop my own I.E.P. for how to paint with watercolors. I knew that I did not have the patience for masking fluid, or layering colors on top of each other only to wait for the washes to dry. That's just not me—I'm more of a "hit and run" painter who likes to get in and get out so I can move on to my next piece.

I've always been the type of person who is willing to work hard and strategically over time to gain success and see improvement. But when I'm painting, I have a tendency to fret over the details. So my I.E.P. had to respect that no aspect or component could become so precious that any fretting is required. Without this requirement, my constant quest for perfection may stop me from ever finishing a painting.

And so began my development of **Three Step Watercolors**. This recipe for successfully working with watercolors is not perfect, and may not even be "correct"—but it does create beautiful watercolor paintings, is a lot of fun and is very rewarding.

Three Step Watercolors is about strategy… many great painters are one click away on the internet. Watching them paint can be as wonderful as listening to an opera. I admire them greatly. This book is not an opera; it is more of a "sing around the campfire" approach to watercolor painting. How you implement **Three Step Watercolors** will be as individual as you are. As you become more comfortable with this process, you will make discoveries and improvements that not only fit your personal style, but help you more effectively express and convey your feelings and perceptions through your paintings.

Because **Three Step Watercolors** is based on starting with your darkest values and working toward your lightest, this approach is probably considered unconventional, even "backwards" to some purists. But, being slightly dyslexic and unable to remember my left hand from my right, I needed a "map" to follow. Before I developed this system, I would start painting without a real plan, and could never understand why one painting would work and another wouldn't.

I do not approach watercolor painting as a sport or competition. Watercolor painting is about working with colors harmoniously, developing your talents and skills, enjoying yourself and expressing yourself creatively. **Three Step Watercolors** teaches you how to create beautiful watercolor paintings quickly.

Three Step Watercolors is more of a guide than a set of rules—there are no right or wrong ways to implement it. You can use these steps in many different ways because the system provides "trail markers" to help you find your way and apply your own personal style. This system eliminates the guess work, and helps you plan more effectively so you can make better choices about the subjects you decide to paint, how to express them in your paintings.

Chapter One: How It Works

This recipe is based on the NOTAN principle. Originating in Japan, NOTAN is a design concept involving the play and placement of light and dark, and how they can be most effectively juxtaposed in art and imagery. NOTAN basically is an image of just black and white color shapes (no grays). The underlying pattern of dark and light are what create beautiful paintings. With a good balance of dark to light within a wide range of values, you may be surprised at what a talented watercolor painter you can become.

Let's begin!

Transferring a Drawing

Everyone approaches transferring the drawing from different places. One main reason is that you won't always have a photograph to start from.

I like to start with a photograph, and draw an image that is even smaller than the photo because small is easier for me to draw. From there I upscale using the grid system. Many painting and drawing books go into the process of transferring a drawing in depth using the grid system.

If you aren't comfortable with your drawing skills, you can always trace the photograph, and scale up using the grid system. Some painters don't even draw or trace, they just go ahead and paint. Do what works for you.

Chapter One: How It Works

Color Values

We'll begin by defining color values in general. For a more in-depth understanding of color, **Color Theory** by Patti Mollica (who is a very talented painter) is a wonderful short and sweet recipe book on color. If you are really interested in learning all you can about color, pick up a copy of Charles Reid's **Painting What (You Want) to See: Forty-Six Lessons, Assignments, and Painting Critiques on Watercolor and Oil**.

Color values are basically your definition of the color groups you will use for light and dark. Using the gray scale image shown in Figure 1, you can see that an ultra marine blue appears as a dark gray along the gray scale. Lemon yellow appears as white.

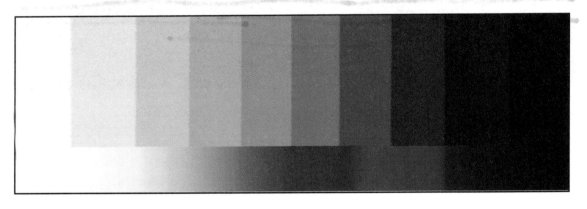

Figure 1. Gray and color scale

Another way of looking at color values is imaging what any specific color would be transformed to in a black and white photo. For example, in a black and white photograph showing a man wearing a medium red shirt, the black and white image of the medium red shirt would show as a light gray. That would also be true if he was were wearing a light green shirt. The photograph would still show a light gray shirt.

As the artist, you can now make the decision of what color, within the gray scale color scale, to make that shirt. Because you can chose many different colors to work within a color value, you can create dramatically different paintings from the same image.

The most difficult color values to determine, of course, are those in the middle, or mid-tones. Colors that typically fall into this category are oranges, light blues, reds and greens. But as you work more and more as a painter, you will begin to more easily see how mid-tone colors identify and correspond to the gray scale. We'll discuss mid-tones in more detail later.

Triads—The Power of Three

Mixing your own colors creates harmony in your work. A "triad" refers to any three colors. I usually choose a blue, a red and a yellow, except for when I am working with massing your darks. Then I often choose ultra marine blue, alizarin crimson and burnt sienna.

The trick is to not allow your triad colors to mix into one puddle, but to create individual puddles to dip your brush in. Cleaning your brush every time you change color helps keep the colors pure, and allows the tones you're working with to mix and mingle in the areas you have massed.

No dabbing or scrubbing! The colors will join each other as wet patch next to wet patch mix together, giving your painting richness in color and depth.

Charles Reid provides an in depth explanation of triads both for oil and watercolor painters. In his book, he provides many examples of triad mixes to choose from depending on what you are trying to convey.

When working with triads, always be mindful of the color wheel and that any yellow, red or blue make for good triad applications.

Chapter One: How It Works

One way to know if you are on the right track while painting is to keep an eye on your pallet to make sure you always have three separate colors. If you do, you're on the right track. But if you have one puddle of brown or gray, your triad is no longer defined, and you have lost the power of the individual pigments.

With practice, you will soon discover sets of triads that are pleasing to you and become your personal signature. I always have fun discovering new combinations.

Before beginning the three steps, see if you can find some triads you like for each step.

- Step One will require triads for the darkest darks.

- Step Two will require triads for your mid-tones.

- Step Three will require triads for the lightest washes.

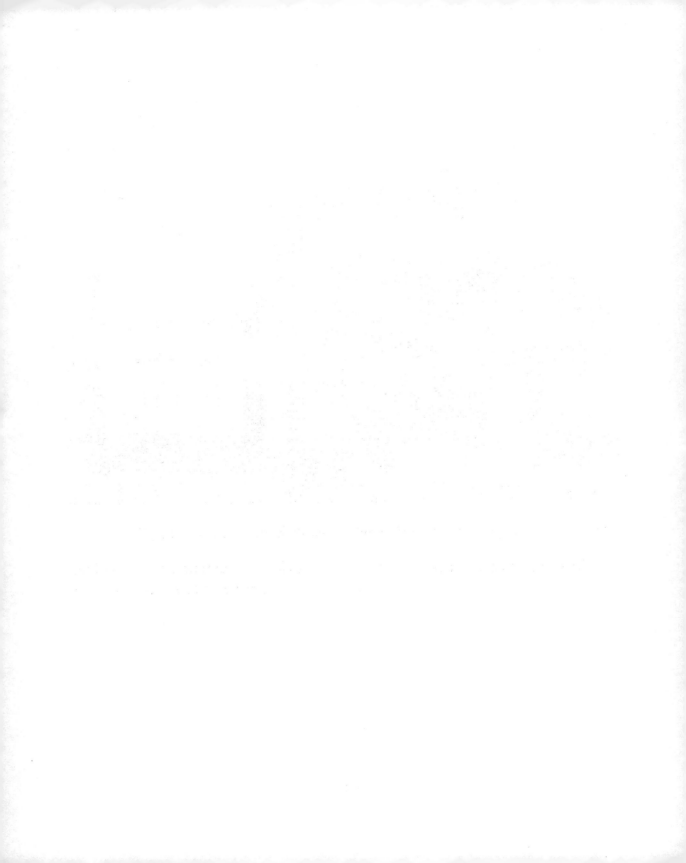

Chapter Two: Tools You Will Need

Working with watercolors requires a few tools that can help you create robust paintings that easily hold their own next to their oil and acrylic counterparts.

Basic Tools for Determining Value

- A gray scale value index card to help you identify color values like the one shown in Chapter One page 26. You can find gray scales at your local art supply store, or from DickBlick.com or DanielSmith.com.

Although not necessary, I've found the ValueViewer phone app (https://itunes.apple.com/us/app/valueviewer/id431548079?mt=8) to be extremely helpful and a great alternative to a standard gray scale index card. This app turns any photograph into a black and white photo, or gray scale or a NOTAN pattern. Although ValueViewer wasn't available when I first developed the The Three-Step Process, once I used it, I knew that I would never go back to the gray scale value index card.

ValueViewer works by allowing you to take a picture using your iPhone or iPad. With this image, you can have ValueViewer transform the image into a black and white photograph, or a black and white NOTAN, or a NOTAN with levels of gray. This app helps me find those pesky mid-tones quite easily. The great thing about ValueViewer is that you can go back and forth between these images easily to help you gather all the color value shape information you desire.

Chapter Two: Tools You Will Need

If the image you load to ValueViewer doesn't clearly display color value shapes, the image does not have a enough contrast (or a good enough "value pattern") to make a successful painting.

- A piece of red plexiglass (preferably 3" x 4") to help you identify color values. Red plexiglass will turn all images (live or on paper) into darker or lighter shades of red.

These shades of red will help guide you when determining which Color value to use relative to an image's actual colors. The lightest reds will be your lightest color values, and the darkest reds will be your darkest color values. Figure 3 shows the piece of red Plexiglass that I use.

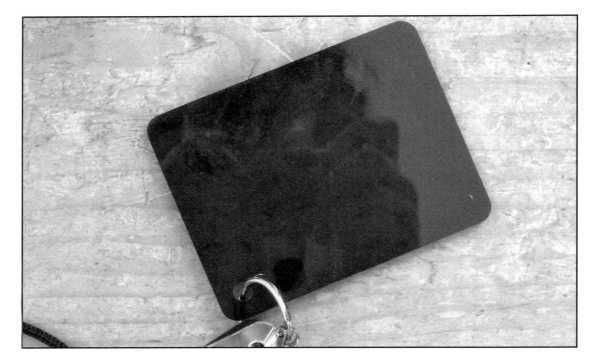

Figure 2. Red Plexiglass

I purchased my red plexiglass from Peggi Kroll Roberts (KrollRoberts.com). Peggi has very useful kit called the MVP (for mirror, viewer, plexiglass and grid planner). Although any red piece of red Plexiglass will do, I personally like Peggi's because I can wear it around my neck so I don't have to hunt for it during a session. (When I paint, I need everything at my finger tips and easy to manage.) Peggi's Artists MVP is the one tool I use with every painting because it helps me find gray scale colors that are hard to follow.

- The next basic tool you need is the ability to squint. Yes, that's right, **squint**. So don't get better glasses as you really don't want to see very well at all. You want everything to blur. I have literally written a reminder to squint on my easel because squinting is absolutely necessary—it allows you to see images in a blur as well as clearly, so get used to the idea of squinting.

- The last basic tool you will need is a space with good lighting. I seldom paint at night because incandescent light from standard bulbs tends to add a yellow tinge. That said, I know many painters who do their best work at night using full spectrum bulbs which completely eliminate yellow tinge.

Brushes, Paints and Paper

- You must have quality brushes. I use flats and some rounds (available at DickBlick.com and DanielSmith.com). Some brushes are made from real fur, and subsequently hold lots of water and pigment. Although expensive, they are a great value because they last much longer than other brushes I've used, and save time by keeping your frustration to a minimum. The best analogy I can think of for quality brushes is cooking. You can use either margarine or butter, but which ingredient will give you more tasty results? Professional bakers always use butter.

Chapter Tw:o: Tools You Will Need

- For paints, I prefer Windsor Newton and Daniel Smith Watercolors (available at DanielSmith.com), but many fine brands are available and easily found on the internet. Windsor Newton and Daniel Smith Watercolors come in tubes that you squeeze to put pigment on a pallet.

You will be adding water to your paints to mix colors and achieve your desired consistency. When working with consistency, think "watery gravy." Because colors lighten when they dry. So use paint that you think you will need. Paint is your friend, and with practice, you will learn to compensate for all types of variables. As with mid-tones, practice and experience will teach you how much water to add. Figure 4 shows the color pallet I use.

Figure 3. Jo's Color Pallet

I like to place my colors on the pallet in the following groupings:

Yellows

- Cadmium Yellow light
- New Gamboge

Reds

- Cadmium Red Medium
- Alizarin Crimson
- Perm Magenta

Blues

- Ultra marine Blue
- Colbolt Blue
- Cadmium blue
- Prussian Blue

Greens

- Cascade Green
- Veridian (Daniel Smith brand)

Neutrals

- Naples Yellow
- Aureolin
- Yellow Ochre
- Burnt Sienna
- Burnt Umber
- Indigo

Chapter Tw:o: Tools You Will Need

Nix black and white pigmentations, you won't be needing them.

- Good quality paper is important. I use Arches 140 pound cold press on a block because it does not have to be stretched or sized. The cold press block allows you to remove a finished painting by simply running a thin knife under the painting and a fresh, clean sheet appears. Blocks contain twenty sheets and come in many easy-to-use sizes.

Part Two
The Three Steps Process

Chapter Three: Step One
Mass Your Darks

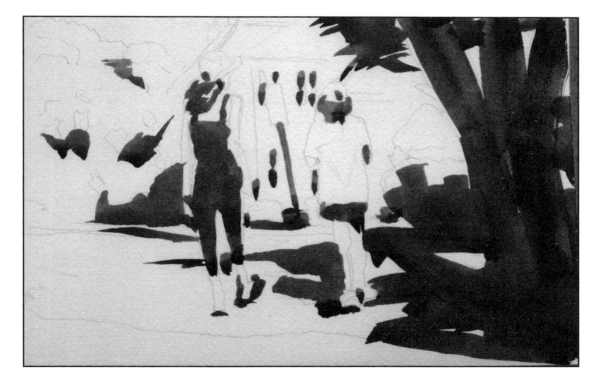

Figure 4. Step One of The Stroll

Chapter Three: Step One— Mass Your Darks

1. Choose a good photograph to work from (you can find many online sites that will allow you to download photographs that are not copyrighted). I either take my own photographs or ask permission to use photos I see on the internet. Look for photos that have strong contrasts of dark and light because those contrasts will become useful information. If the photograph does not have clear contrast, your painting won't either.

2. Look at your photograph to "mass the darks," or find the darkest elements. Massing your darks is when proper lighting, squinting and using a Color value finder are most important. You are looking for shapes and color values rather than individual concrete objects. Although your photograph can, for example, have a tree next to a flower pot, try to not see the individual objects. Just look for color values and shapes.

 To really experience the difference between seeing overall color value and shape as opposed to individual objects, try looking at the photo upside-down, and perhaps even try painting the subject upside-down. Approaching a painting through the lens of color value and shape allows your eyes to travel over the picture without seeing individual objects.

3. Note how the color values and shapes connect. These connections will become the underlying pattern for your painting.

4. Load your brush using a dark pigment mixed with water that represents your darkest Color value.

5. Make small dabs with your paint brush on a separate sheet of paper. These colors will be your darkest darks. After massing your darks, you will only use colors that are lighter than these foundation dabs.

6. Paint the dark pattern you see in the photograph. Don't make any judgments here about what you see developing on your paper. Paint what

you see—not what you "think" you see. Move slowly and purposely and get that pattern established.

7. Allow the paper to dry completely. I use a hair dryer but you can also enjoy a cup of tea. However, if you live in a dry warm climate, your paint will probably dry before the tea kettle boils.

Chapter Four: Step Two
Mid-Tones

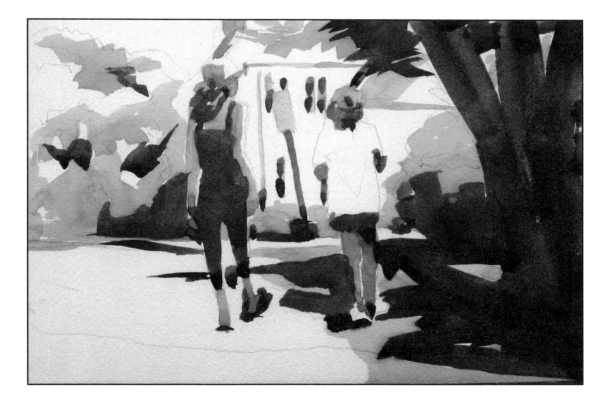

Figure 5. Step Two of The Stroll

Chapter Four: Step Two—Mid-Tones

1. Look at your photograph using the red plexiglass to find mid-tone patterns that are not as dark as what you established in Step One. **Never go darker than you did in Step One**.

 Mix a color with water and make a test dab next to your dark foundation dab to create your mid-tone foundation dab from Step One. Is it lighter than your dark foundation dab? If not, lighten your mid-tone dab by mixing in another color or adding lighter pigment. Don't rely solely on water to get a lighter color and do not be timid to play with colors! Experimenting with mid-tone colors will help you learn the color spectrum that will become your personal mid-tone colors. During this step, you will create lots of test dabs, and that is good. Have fun creating a variety of colors during the mid-tones step. With time and practice, you will learn to instinctively find your favorite colors.

 Remember, for each mid-tone test dab you create, check to make sure that it is lighter than the color you established for your dark foundation in Step One. No mid-tone can be darker than what your established as your dark foundation in Step One—this is where discipline and commitment are crucial. Stay with the plan, this is not the time to go crazy. Stay focused.

2. Paint the mid-tone patterns you see in the photograph. Move slowly and purposely and get that pattern established. Adding mid-tones is when you will really see if you have a successful painting or not.

 Allow the paper to dry completely. Now let's go on to the last final step, Step Three.

Chapter Five: Step Three
Finishing Touches

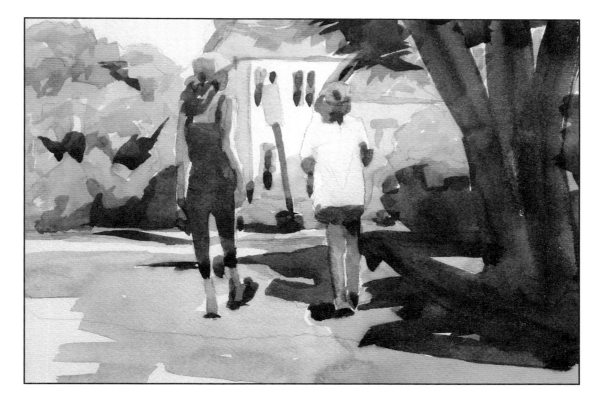

Figure 6. Step Three of The Stroll

Chapter Five: Step Three—Finishing Touches

1. Begin mixing colors that represent the lightest color value. In this step is I use "washes," which are transparent and smooth. Washes are a color mixed with more water than pigment. The key to working with washes is to mix more than you think you will need. Paper is "thirsty" and will soak up a lot of the paint that you apply—and you will have no time for mixing more color during this step.

2. Apply washes quickly and evenly. Never scrub or even try to touch a wash with your fingertip because you can very easily create a "bloom," or balloon-like irregular shape.

With time and practice, you will get a feel for how much wash to put on your paintbrush. If you do create a bloom, try dabbing it very carefully with a paper towel, or just let it be. **Blooms happen!**

Part Three
Putting it Together

Chapter Six: Final Tips

Now that the **Three Step Watercolors** process has been established, here are some final tips to keep in mind. The first is Limited Strokes.

Limited Strokes

Every time you mix a color and put your brush to paper, you are making a stroke. With each stroke, you are dulling down the color. In essence, each and every stroke introduces a new layer of paint, and with more paint, less white from the paper can come through.

So in order to keep vibrancy and a sense of light, **use limited strokes**. Use large brushes to create large strokes; large brushes exist for the very purpose of minimizing layers of strokes.

An exercise that will help you gain confidence with using limited strokes is to set-up an apple and paint it. Count how many strokes you use. To make counting easier, after each stroke make a dab on a piece of paper. Set a timer for five to eight minutes and stop when your time is up. Now move the apple and try again using as few strokes as possible. See if you can paint that apple in five to ten strokes.

Chapter Six: Final Tips

Allow Colors to Intermingle

Never scrub paint onto the paper. Place wet patches of the same color value next to wet patches of the same Value, and a wonderful intermingling will occur. This intermingling of color is the magic of watercolor.

Be Flexible

Some paintings will require more than three steps. Sometimes, even when you have made your color value decisions, and have followed the plan, your painting can appear pale (see examples in the Appendix of Paintings). Sometimes you will have to go back and strengthen your painting by adding more saturated color. **Do not change any values**—stick to the values you have.

Surrender Dorothy!

Approach your painting from a place of surrender, and when you're finished, walk away. Do not dab or mess with it.

Allow the paint, paper and your energetic signature do the work. Once you make the major color value decisions, get out of your own way and allow your painting to evolve.

Conclusion

We are all guilty of getting fussy with watercolor. With time and practice, you will experience that "less is more." Trust the paper and paint, and surrender to the process. The paint always seems to know where it needs to go.

Your painting may not be perfect, but with time, patience and practice, you will get a feel for your own personal style.

I believe Art should be a conversation. If you'd like to converse, please contact me at: Jowatercolor@gmail.com, or through JoMackenzie.com or JoMackenzie.blogspot.com. You can also find me on facebook fan page at Jo Mackenzie Watercolors.

In the following Appendix, you'll find samples of paintings showing the three-step process. As you will see, the process is not written in stone, and some paintings have less steps, some have more. The overall concept of always having a strong underlying NOTAN pattern followed by mid-tones is consistent throughout all the paintings. The two most important steps, your underlying mid-tones and NOTAN pattern, are easily seen in each of the paintings. The last step is where you will do overall light washes and/or add a background, often of a complimentary color, to make your painting pop and make final adjustments. It is imperative, though, whatever final adjustments you make, do not deviate from the original plan.

Enjoy!

Part Four
Appendix

Appendix Intro

The Appendix is full of watercolor painting images by step. As you can see, stunning paintings can be created in two, three, or more steps.

Some paintings show the corresponding color pallets, some show the original photo. The first series, Otis the Lab shows the most detail with corresponding color pallets, the original photo and an image showing how your red plexiglass helps define the first step, dark mass colors.

The purpose of the Appendix is to illustrate how each step builds upon the previous step to create beautiful watercolor paintings. You may notice that the colors in each step don't always match perfectly. The lack of color matching is due inconsistent lighting as I photographed each step. When you work with color values using the red plexiglass, you will be making decisions on each value **as it relates** to the color previously chosen… so even though the following photographs are at times inconsistent in the values shown, following the three step process by working from darkest values to lightest values will produce impressive results.

Otis the Lab

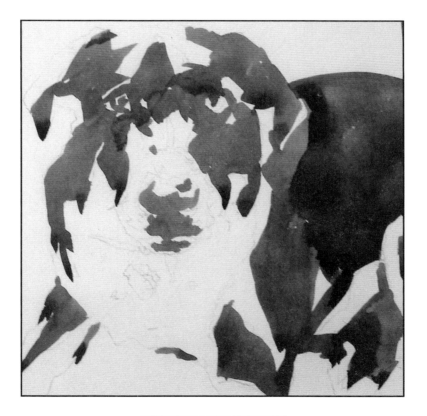

Figure A-1. Step One of Otis the Lab with selected dark mass colors

Appendix

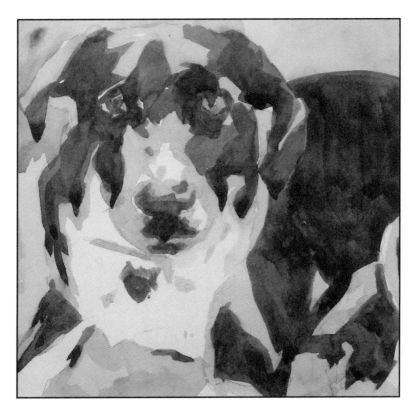

Figure A-2. Step Two of Otis the Lab showing mid-tones

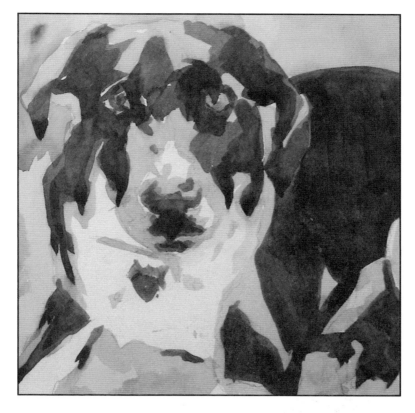

Figure A-3. Step Three of Otis the Lab showing finishing touches

Appendix

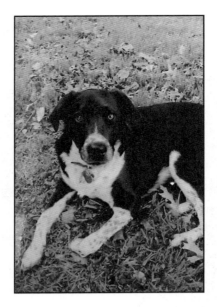

Figure A-4. Otis the Lab original photo

Figure A-5. Step One of Otis the Lab with red plexiglass showing dark mass colors

Freedom the Shepherd

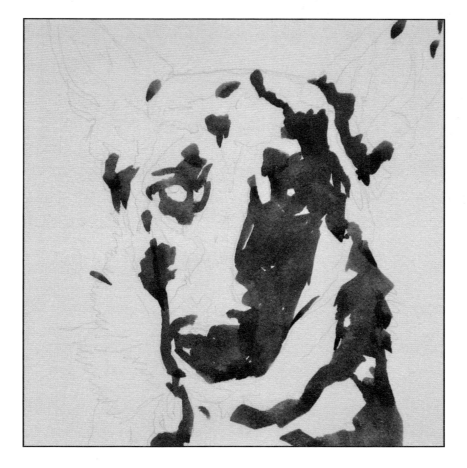

Figure A-6. Step One of Freedom the Shepherd showing dark mass colors

Appendix

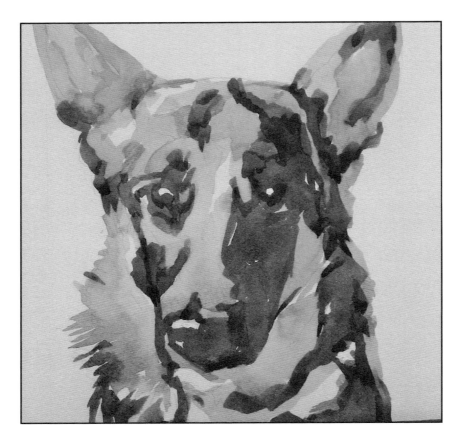

Figure A-7. Step Two of Freedom the Shepherd showing mid-tones

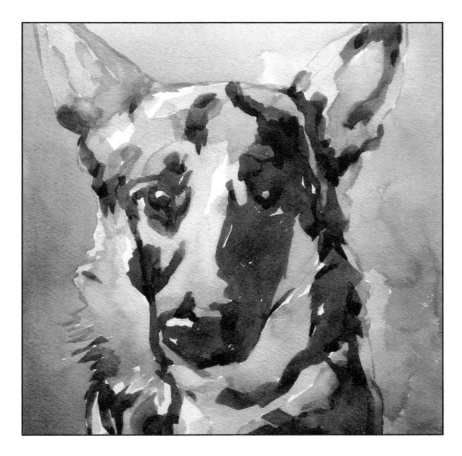

Figure A-8. Step Three of Freedom the Shepard

Figure A-8 shows the third step where the masses are dark, mid-tones have been established and white of the paper is left as the lightest value. This approach allows you add any background you choose (because decisions have been made, and your work is done).

Rascal the Terrier

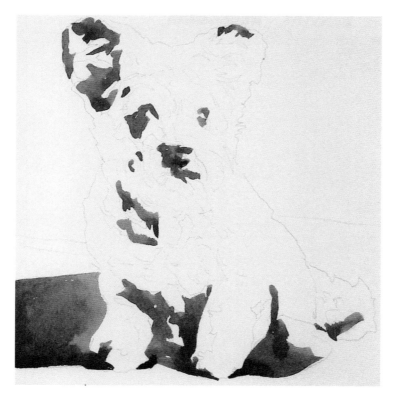

Figure A-9. Step One of Rascal the Terrier showing dark mass colors

Appendix

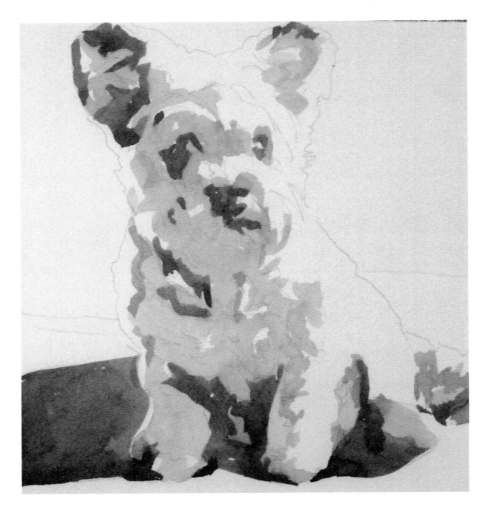

Figure A-10. Step Two of Rascal the Terrier showing mid-tones

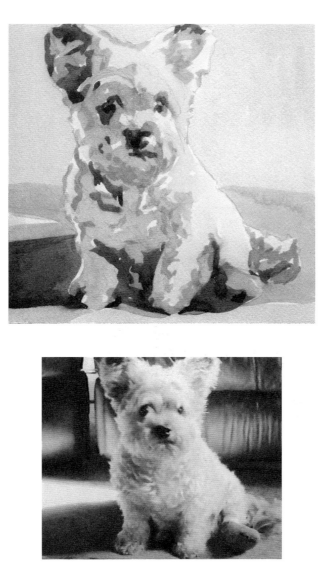

Figure A-11. Step Three of Rascal the Terrier showing the original photo

Tucker the Retriever

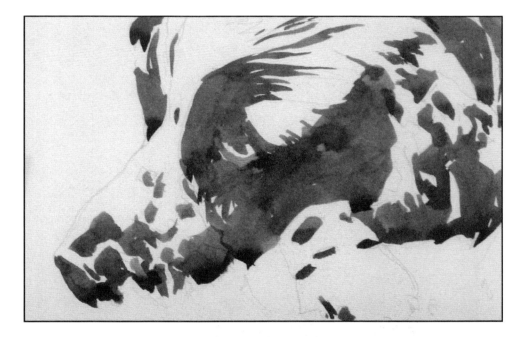

Figure A-12. Step One of Tucker the Retriever showing dark mass color

Appendix

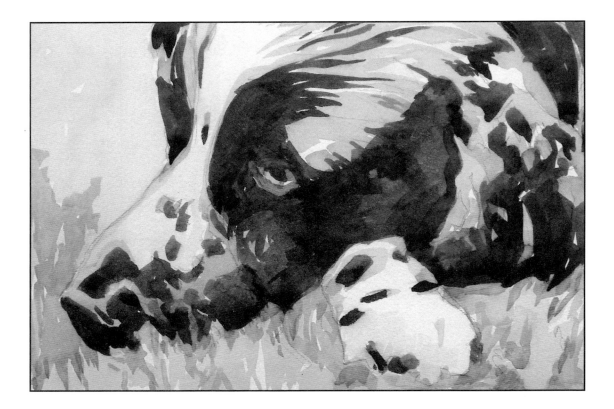

Figure A-13. Step Three showing Tucker the Retriever showing finishing touches

Tucker the Retriever is an example of a beautiful two step watercolor painting.

Brie the Cat

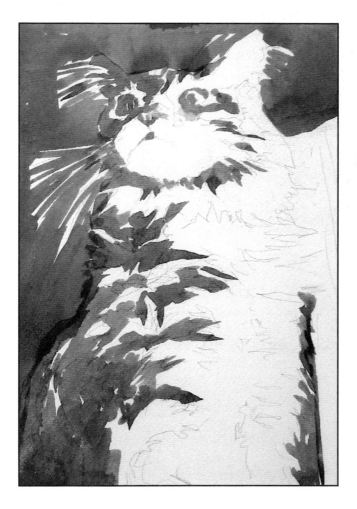

Figure A-14. Step One of Brie the Cat showing dark mass colors

Appendix

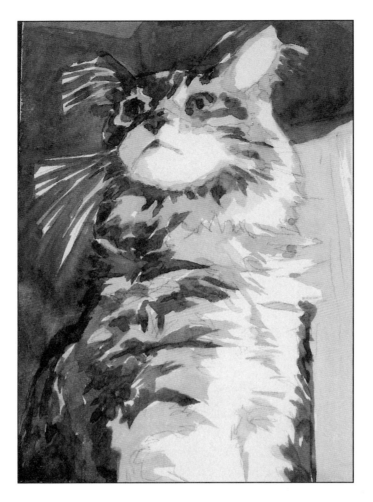

Figure A-15. Step Three showing Brie the Cat showing finishing touches

Brie the Cat is an example of a beautiful two step watercolor painting.

.

The Kitten

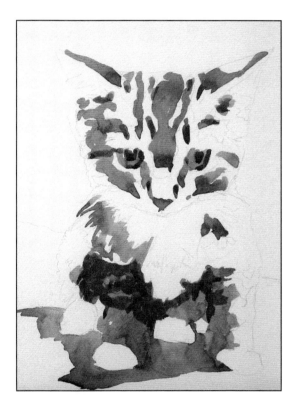

Figure A-16. Step One of The Kitten showing dark mass colors

Appendix

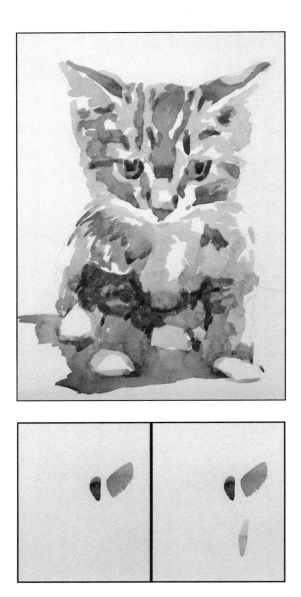

Figure A-17. Step Two of The Kitten showing mid-tones

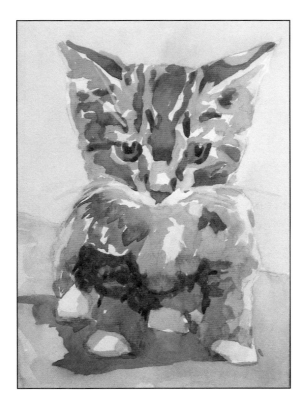

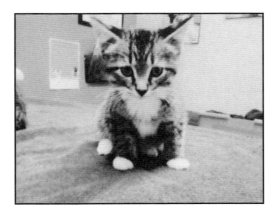

Figure A-18. Step Three of The Kitten showing the original photo

The Cottage

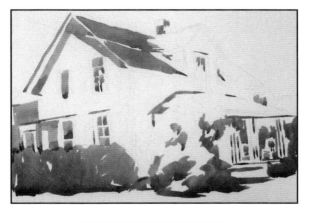

Figure A-19. Step One of The Cottage with selected dark mass colors

Appendix

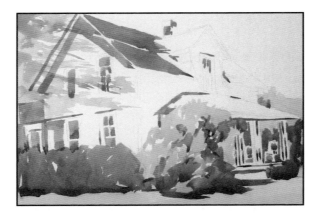

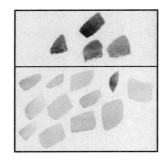

Figure A-20. Step Two of The Cottage with selected mid-tones

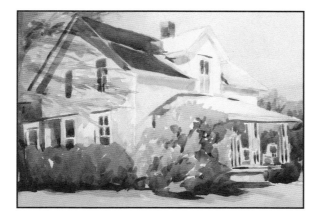

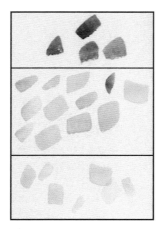

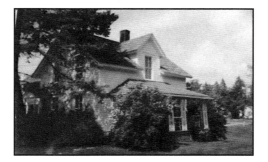

Figure A-21. Step Three of The Cottage with selected finishing touches and the original photo

The Barn

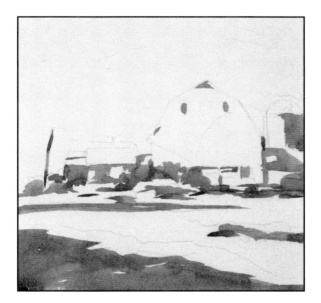

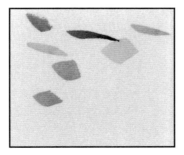

Figure A-22. Step One of The Barn with selected dark mass colors

Appendix

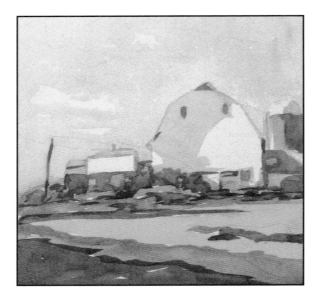

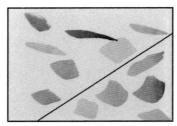

Figure A-23. Step Two of The Barn with selected mid-tones

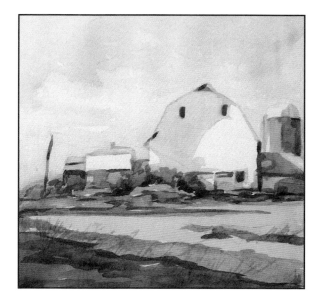

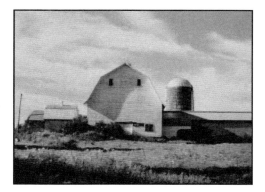

Figure A-24. Step Three of The Barn with selected finishing touches and the original photo

The Farmhouse

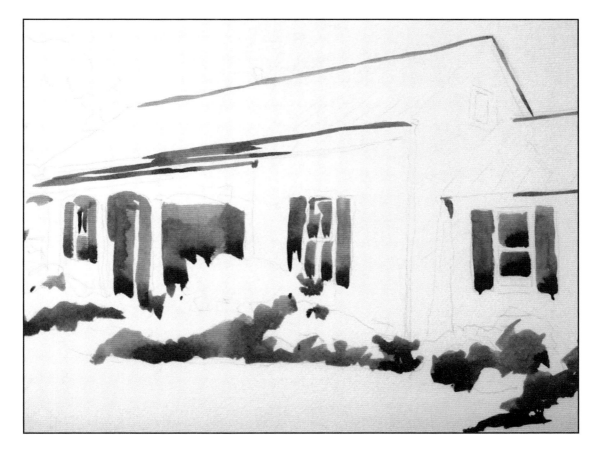

Figure A-25. Step One of The Farmhouse with selected dark mass colors

Appendix

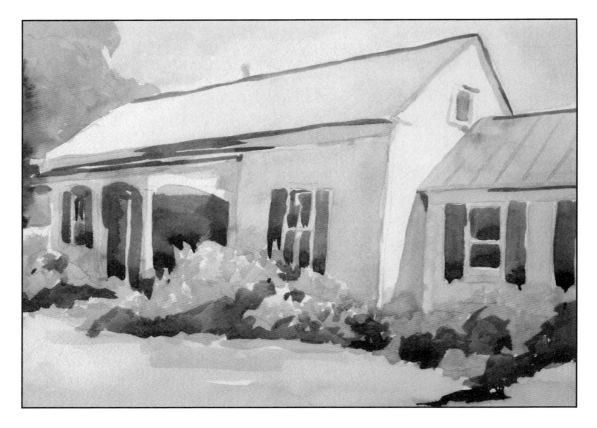

Figure A-26. Step Two of The Farmhouse with selected mid-tones

The Farmhouse is an example of a beautiful two step watercolor painting.

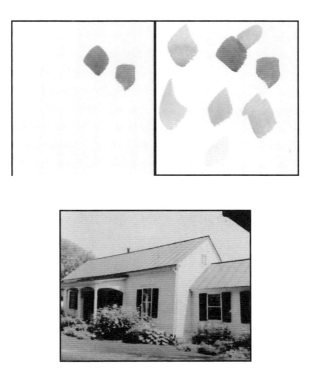

Figure A-27. Mass dark color and mid-tone color pallets with the original photo

Tiffany's House

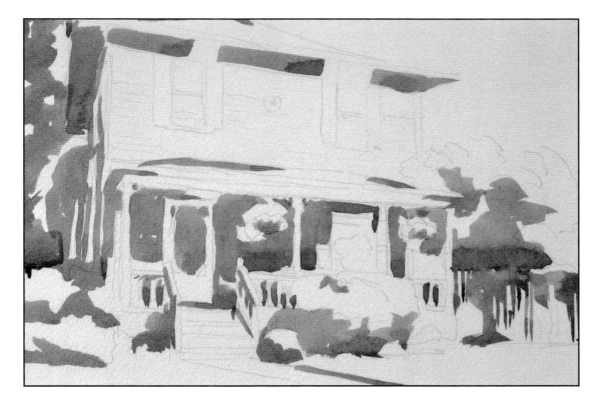

Figure A-28. Step One of a Tiffany Box House showing dark mass colors

Appendix

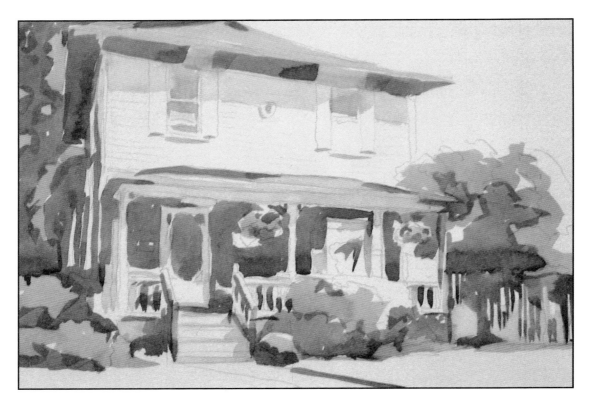

Figure A-29. Step Two of a Tiffany Box House showing mid-tones

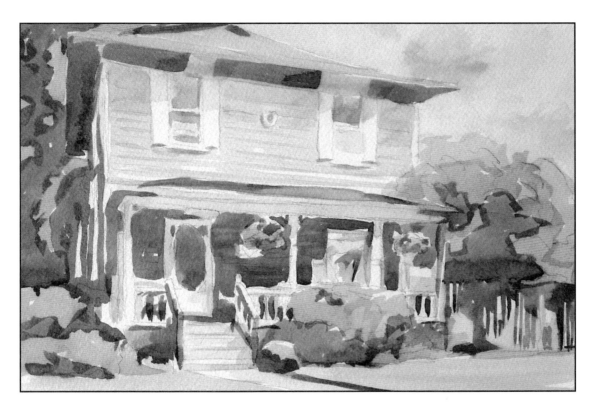

Figure A-30. Step Three of a Tiffany Box House showing finishing touches

Sunshine Dappled House

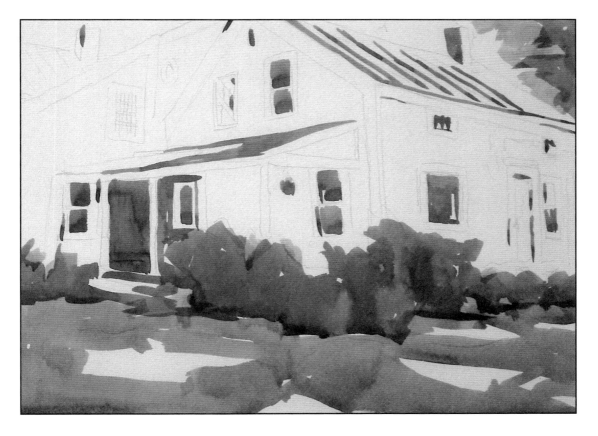

Figure A-31. Step One of Sunshine Dappled House showing dark mass colors

Appendix

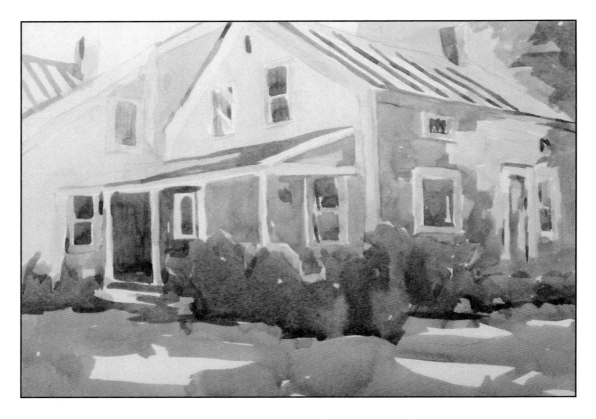

Figure A-32. Step Two of Sunshine Dappled House showing mid-tones

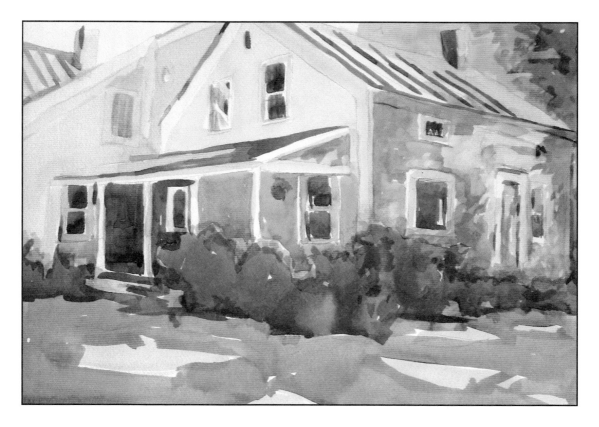

Figure A-33. Step Three of Sunshine Dappled House showing finishing touches

Make-Up

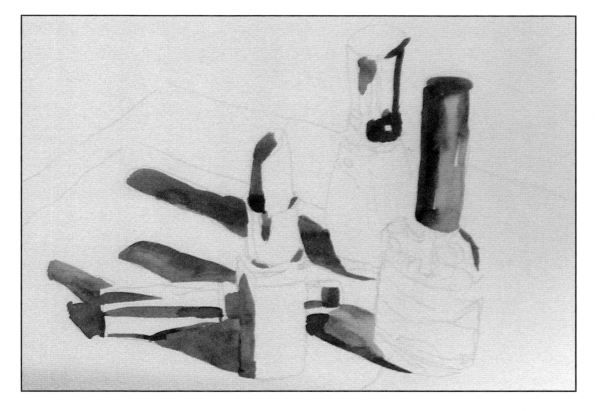

Figure A-34. Step One of Make-Up showing dark mass colors

Appendix

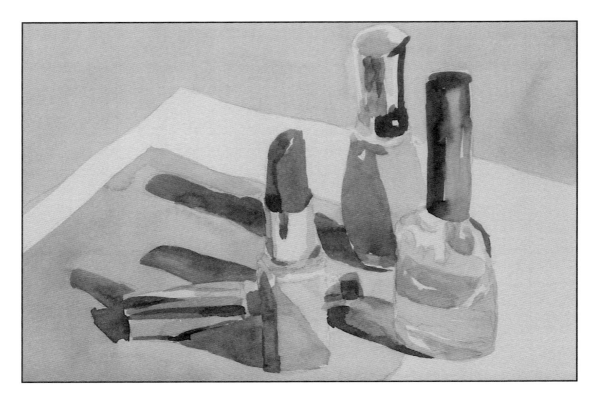

Figure A-35. Step Two of Make-Up showing mid-tones

This is an example of following the Three Step Process, but not feeling happy about the results of at the end of Step Two. I used some color washes over certain areas to make the colors more saturated, without changing any of the original value relationships.

Make-Up illustrates how to tweak and improve on the Three Step Process when you are ready do to so.

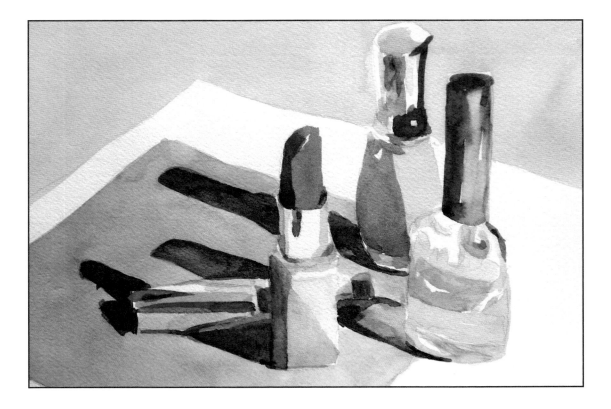

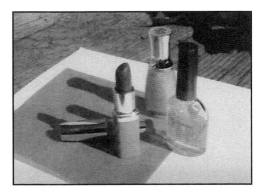

Figure A-36. Step Three showing Make-Up with selected finishing touches and original picture

The Bench

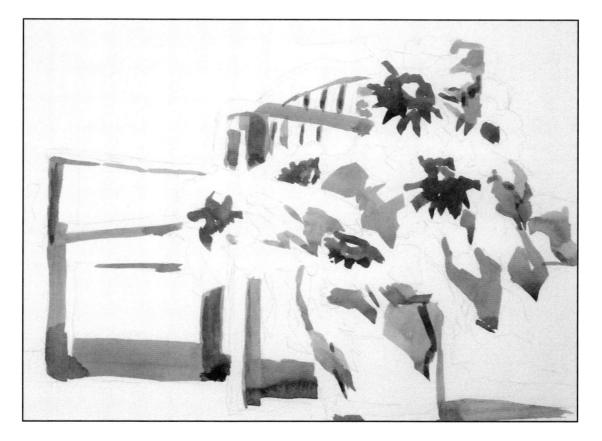

Figure A-37. Step One of The Bench showing dark mass colors

Appendix

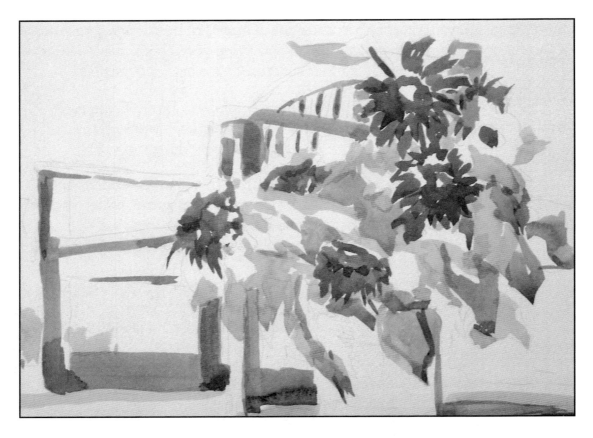

Figure A-38. Step Two of The Bench showing mid-tones

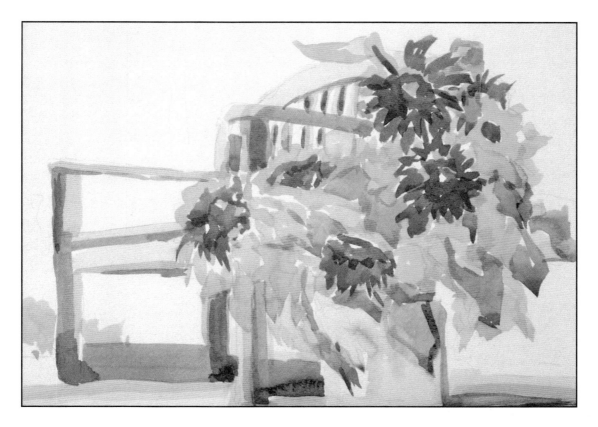

Figure A-39. Step Three showing The Bench showing a second application of mid-tones

Appendix

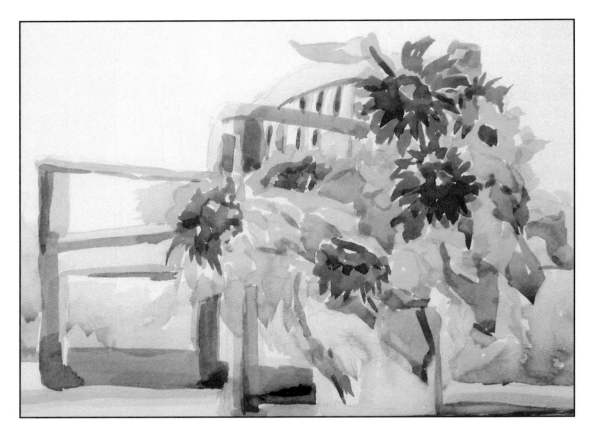

Figure A-40. Step Three showing The Bench showing a third application of mid-tones

The Bench is an example of a five-step painting, where two extra steps of midtone colors were applied.

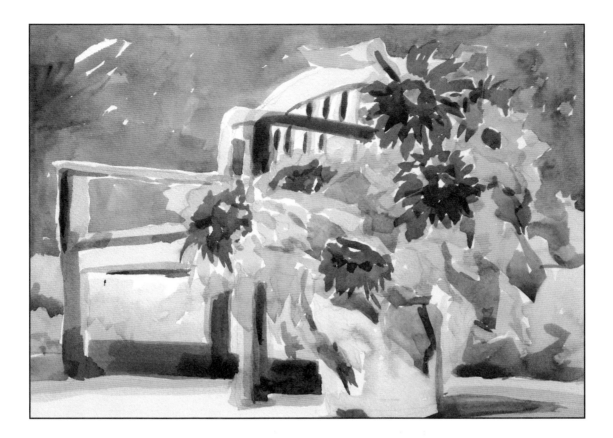

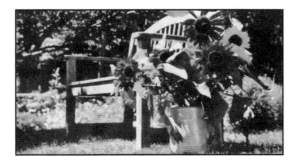

Figure A-41. Step Three showing The Bench with selected finishing touches and original picture

The Tractor

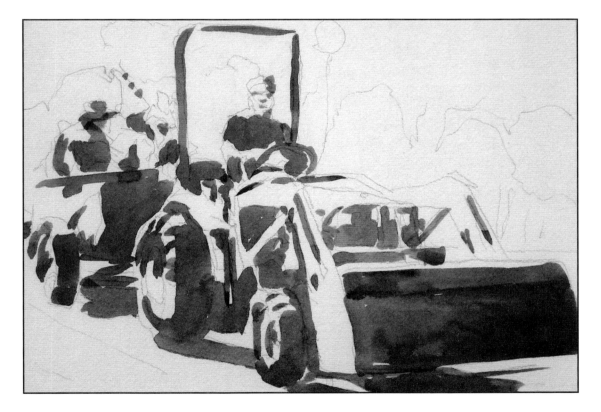

Figure A-42. Step One of The Tractor showing dark mass colors

Appendix

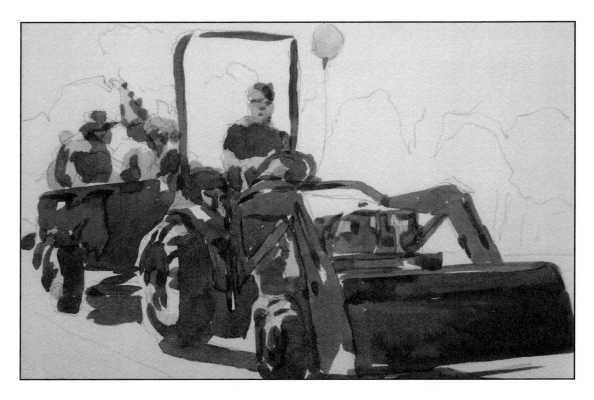

Figure A-43. Step Two of The Tractor showing mid-tones

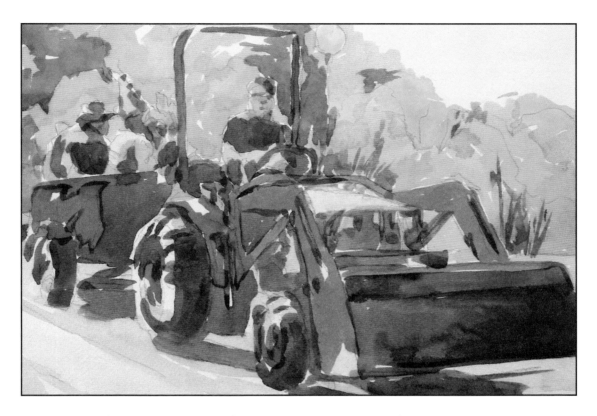

Figure A-44. Step Three of The Tractor showing finishing touches

Play Day

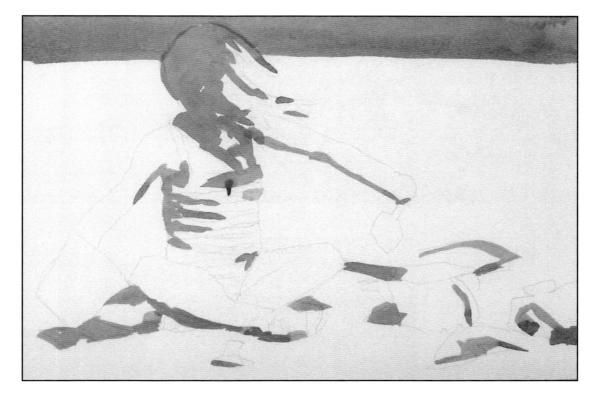

Figure A-45. Step One of Play Day showing dark mass colors

Appendix

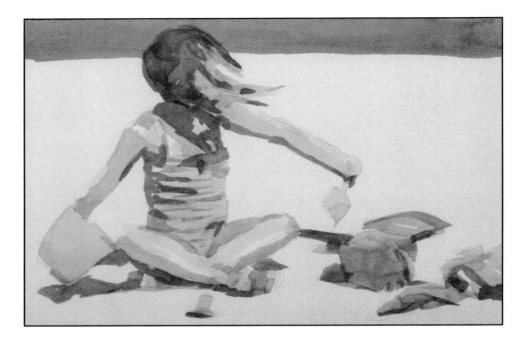

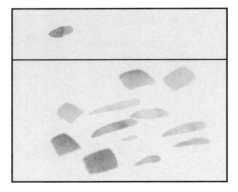

Figure A-46. Step Two of Play Day showing mid-tones with the dark and mid-tone pallet

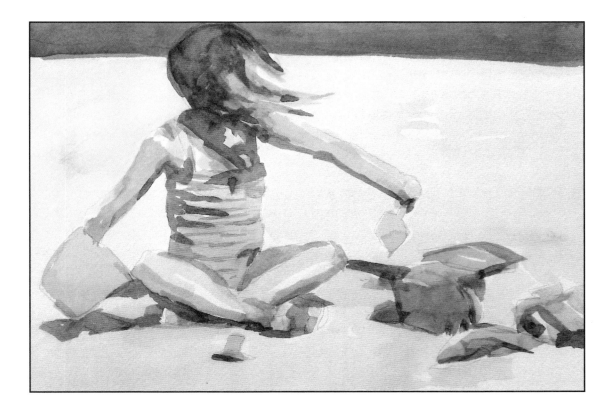

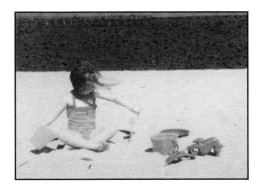

Figure A-47. Step Three of Play Day showing finishing touches and the original photo

What Not to Do

The following paintings show some examples of paintings that do not have a strong underlining NOTAN pattern. The results are not terrible, but they're spotty and the values are disorganized, making the paintings weak.

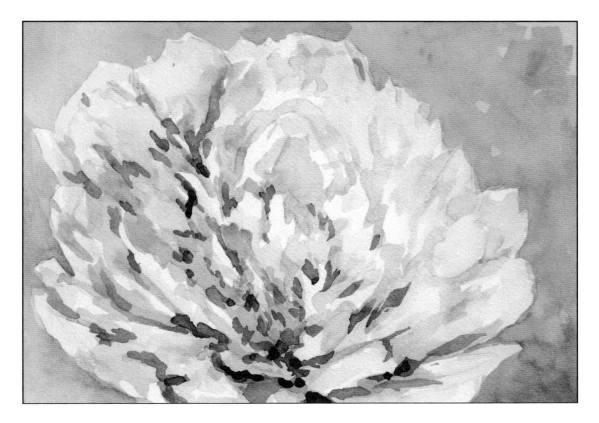

Figure A-48. Dahlia showing spotty problems

Appendix

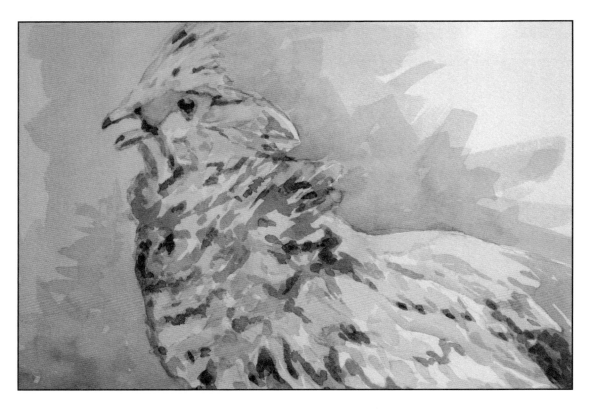

Figure A-49. Partridge showing spotty problems

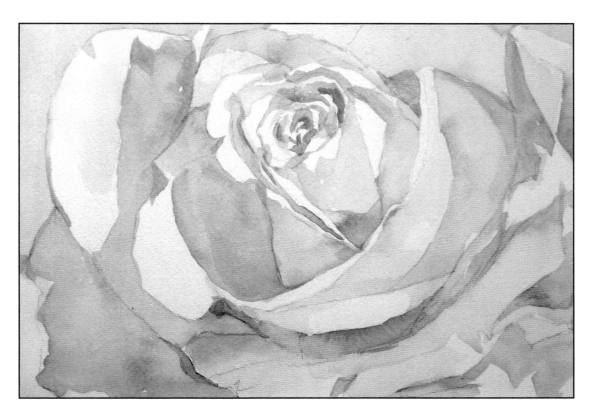

Figure A-50. Rose showing only mid-tone colors

Appendix

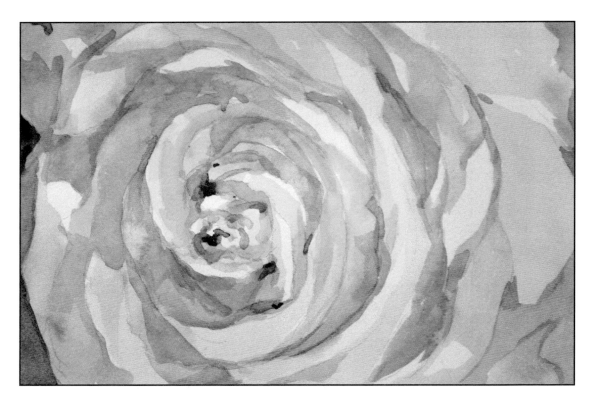

Figure A-51. Rose showing only mid-tone colors and dark spots with no NOTAN pattern

Jo's Archives

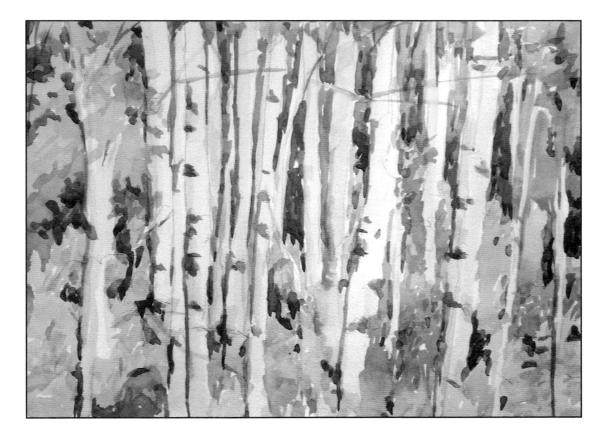

Figure A-56 Birch trees in Autumn

Appendix

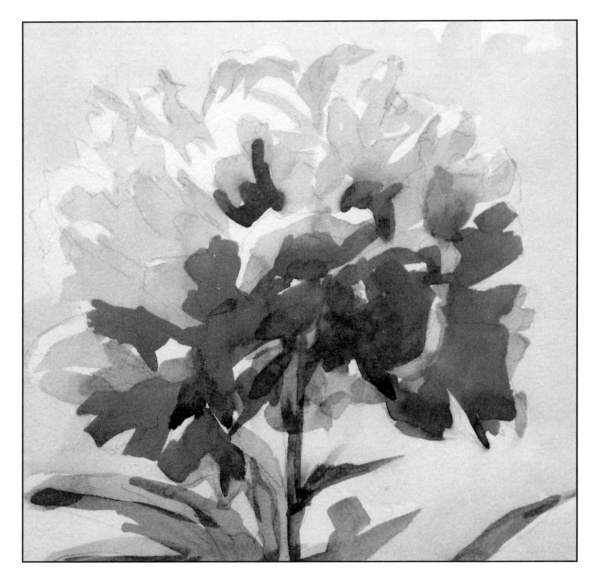

Figure A-57. Peony in blossom

Jo MacKenzie

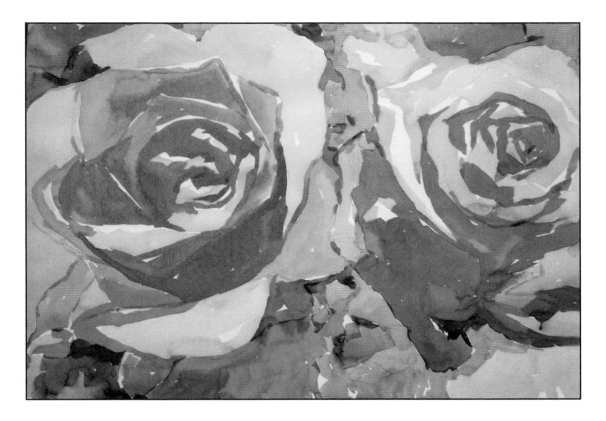

Figure A-58. Roses

Appendix

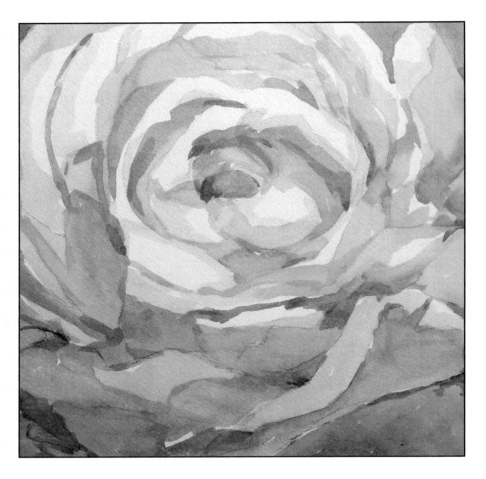

Figure A-59. Yellow Rose

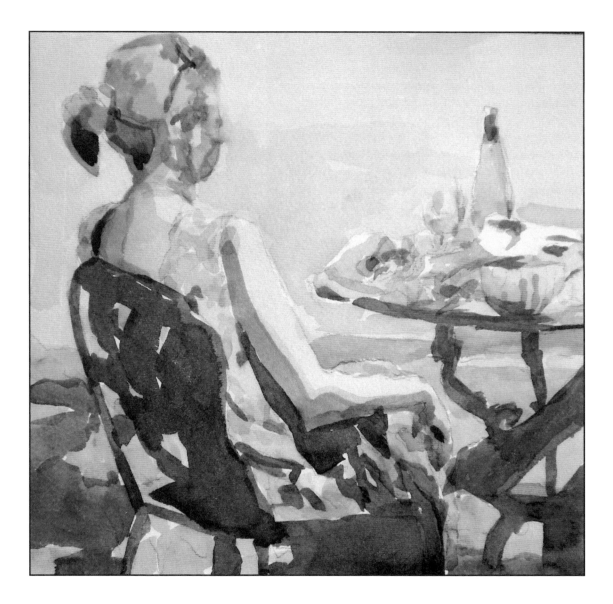

Figure A-60. Summer Table

Appendix

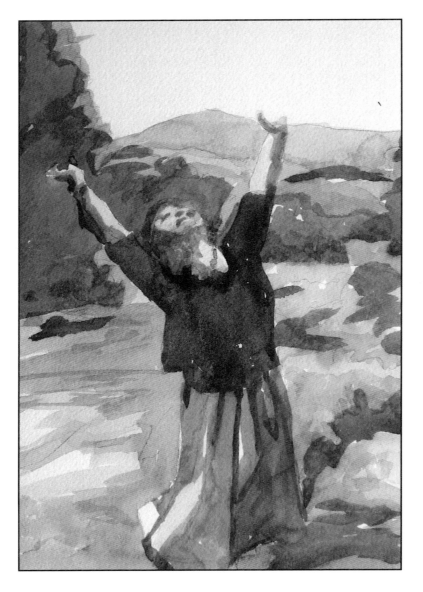

Figure A-61. Joy

ABOUT JO MACKENZIE

Jo MacKenzie is a full time artist living in central Vermont. Her work can be seen at JoMacKenzie.com and JoMacKenzie. blogstpot.com. You can connect with Jo on her facebook fan page (JoMacKenzieWatercolors) where friends meet to discuss art, pets and all things floral.

Jo believes art should be a conversation, not a competition, and strives to keep learning and teaching… as there is always more to come.

Made in the USA
San Bernardino, CA
11 March 2014